CONTEMPORARY BRITISH ARTISTS:
HENRY LAMB
General Editor: ALBERT RUTHERSTON

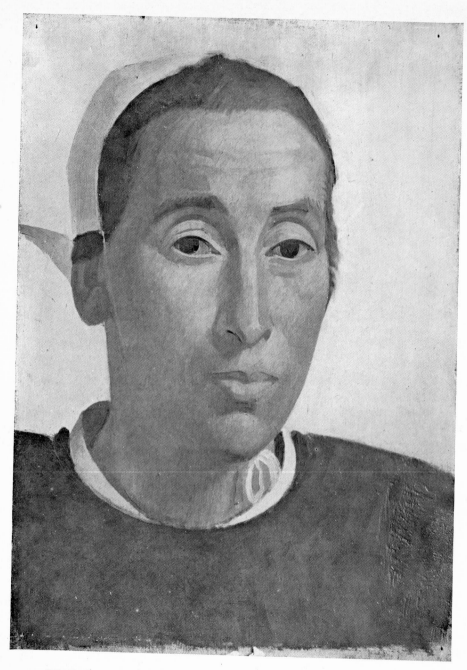

HEAD OF A BRETONNE. (1910). *Oil. In the possession of J. L. Behrend, Esq.*

HENRY LAMB

LONDON: ERNEST BENN, LTD.
8 BOUVERIE STREET, E.C. 4
1924

ACKNOWLEDGMENT

THANKS are due to the Imperial War Museum for the permission kindly given to reproduce the *Palestine War Picture* in which the copyright is the Museum's, and to the Manchester City Art Gallery which owns the copyright in the *Salonica War Picture*.

Acknowledgment is gratefully offered also to those private owners of Mr. Lamb's work who have courteously allowed it to be photographed for the purposes of this volume, and to Mr. Lamb himself for the valuable help he has given.

All copyrights, except where other acknowledgment is made, are strictly the property of the artist.

Made and Printed in Great Britai at
The Mayflower Press, Plymouth. William Brendon & Son, Ltd.

LIST OF PLATES

LIST OF PLATES

HENRY LAMB

THE work of Henry Lamb is ostensibly descriptive in its aims, and the province of art which he has made in a special way his own connects his work directly with the civilization of his own country and time. Mental association is allowed an intrinsic place in his portraits and figure compositions, and even in his landscapes allusion often plays an important part. He has pursued his aims with an integrity of purpose, and a kind of instinctive schooling of his powers which suggests a remote objective, the full scope of which can hardly be taken in, even at this mature stage in his career. What the genre picture may eventually become in his hands it is still too early to guess ; and his work has, in consequence, a curiously interesting and isolated place in the art of the present day.

A certain profound and philosophical assimilation of his subject carries the themes of his genre pictures a long way beyond anecdote and invests his portraits with ample psychological girth ; for in the transparent candour of their delineation, illumined with an insight at once so searching and sympathetic,

the sense of apology for the subject can have no place, and its unctions and amenities no meaning. The singularities fostered by an absorbed or withdrawn life, and the impostures that public eminence sometimes develops, receive in his pictures a kind of good-humoured raillery, more in the tone of gentlemanly intimacy than of ridicule ; and personal peculiarities in his hands derogate nothing from that natural dignity, the original divinity of mankind, which is latent in all his portraits. His people are always presences to which the clothes, the gestures, and the surroundings pay their full tribute of expression. The features are never left with an unfair burden of identity amongst the conventions of drapery or professional attributes.

This same intimate grasp underlies all his work, and is its distinctive feature. With him it is as if beauty had not only to be recognized and felt, but proved in the actual texture of life, before it can be possessed in his art ; and all through his career it is the actual human contacts which provide the quickening of his inspiration.

The influence of contemporary work can often be detected. Augustus John at the outset, Stanley Spencer more recently, and others whose work is less familiar, have an unmistakable bearing on his development. But it is noticeable and characteristic that where his work shows this sort of derived quality, it

is almost always the temperamental outcome of a close personal intimacy or friendship.

To illustrate this peculiar dependence on experience I would compare two pictures, one painted during a stay of a few months in the north-west of Ireland, the other the first of his war compositions. Full as it is of rhythm and insight, the Irish picture seems to lack the quality of intimacy which a longer period of naturalization might have earned for it. The spirit of the country is felt and portrayed, but not possessed, and the lyrical make-up of the design, to which the explanatory style of the painting does not seem altogether suited, has a somewhat concocted look, and fails to supply the coherence which would have followed naturally from a more complete fusion of his temper with the subject. On the other hand, the spirit of the war picture is founded in such deep levels of consciousness that its utterance in visible terms has almost the authentic and inevitable character of a natural phenomenon, to which ordinary canons of criticism hardly seem to apply.

The works reproduced in the present publication form a fairly representative collection. Documentary completeness would have demanded the inclusion of more of those early works painted with a distinctly lyrical intention, which, with a number of small landscape experiments, provided the groundwork of his equipment as a colourist. But after the

three-quarter length female portrait (Plate 2) where this lyrical quality is seen at its best, he does not seem to have carried it further, nor can this portrait be said to illustrate a type of painting with which he has become permanently identified.

Two family groups stand out as first examples of a sort of " genre " portraiture to which his gifts are admirably suited, and the origins of which can be recognized in a quantity of early drawings, full of incisive humour, but always a good deal more than mere caricatures. That of Boris Anrep, the artist to whom the Blake room at the Tate Gallery owes its mosaic floor, is the first, the more experimental of the two. In the family of his architect friend, which followed, his peculiar humour is carried a good deal further, and he seems to have realized more completely the limitations as well as the possibilities of this type of portraiture. The play of character it allows, and the kind of diffused consciousness which relieves the personages from the unnatural burden which, as single figures, they would have to sustain, make of the group composition a charming and humane kind of conveyance. Apprehended at the outset in psychological terms and carried out in undramatic values, it seems to offer the fascinations of an unexplored province in Art.

The importance of the colour becomes apparent in these

black-and-white reproductions. With Lamb this is an integral contribution to the design, completely visualized from the first, and not merely an added grace, as it is with Mantegna, the most easily recognized ancestor of his art. Its positive quality is never compromised in the light and shade of the modelling, and rarely in painting is so little conflict to be found between the subtleties of drawing and colour as in his work. The reproduction of the second family composition accentuates the disquiet of the strange Laocoon-like grouping, and seems to give too much prominence to the somewhat obscure symbolism of the background. The exquisite colour arrangement supplies all that the design needs of cohesion and spontaneity. In his work the mood of the colour scheme is always bound up intimately with the subject, and in the case of Lytton Strachey's portrait the colour seems to strike the one key in which the astonishing conception can be sustained in all its significance.

The facts of his life in their bearing upon his work are as follows : He was born at Adelaide in 1885, and educated at Manchester, where his father, a native of Lancashire, was professor of mathematics at the University. He is Irish on

his mother's side. He was originally destined for the profession of medicine, and it was not until he was twenty years old, when he had almost served his time as a medical student, that he left Manchester to follow the profession of his choice. He had already acquired the rudiments of his craft from Mr. J. Knight, assistant drawing master at Manchester Grammar School. An early friendship with Francis Dodd was a piece of good fortune, paving the way towards his new profession, and giving him, from the first, a true craftsman's perspective of it. The stimulating influence of Augustus John counted for a good deal in the years that followed, spent for the most part in France. Of the contemporary foreign artists with whom he came in contact none seem to have had much influence upon his work, unless possibly Picasso, whose outlook communicated itself to him at one period in his life ; the head of the Breton youth here reproduced reflects it to a certain extent. His return to England in 1911 brought him into contact with all the elements which made the London of the few years before the War the centre of a lively artistic activity, and it was here, in surroundings where his many interests found full scope, that his art first came into its own. It is perhaps not irrelevant to speak of the important part that music has always played in his life ; it is a pleasure which he takes very seriously and to which he devotes as much as one-third of his working day.

14

HENRY LAMB

The War came as something more than an interruption. The resumption of the uncongenial work of his first calling, after so long an interval, meant a second tedious medical apprenticeship, and the laborious acquisition of a mass of technical knowledge for which he destined a very temporary future. He served with distinction as battalion medical officer in Macedonia, Palestine, and France. The botanical studies for which he found time in Palestine were the first experiments in a technique reconstructed to meet the still wider perspective of life which the events of the past few years had opened out for him.

In reviewing his art from its beginnings a few points occur to one which throw light on its character and differentiate his work from that of many others. In the first place, he was never a student in the ordinary sense of the word. There is in his early work none of the engaging clumsiness, or the intriguing obscurity, which one usually associates with a strong temperament struggling for utterance in the refractory medium of paint. Instead we find, even from the first, a lucid and uneventful style at his command. Speculative adventure in the exchange values of expression had few fascinations for him. An assured and melodic use of line provides in his work an element of stable and accepted currency. This, in his early

performances, is generally associated with a design somewhat self-conscious and arbitrary in its individuality. The colour is very much all there ; it is never tentative or naif, but, on the contrary, has in many examples an almost cantankerous assurance.

With this went a certain arrogance which shrank from what might be described as the congregational worships in art ; a distrust of the grand manner in all its manifestations and sanctions, which lasted for many years. His painting owes nothing to those early struggles with technique which so often provide a formative element in a painter's personality, and afford such a valuable preoccupation for a student whose creative impulses are still in their infancy. The idiomatic possibilities of oil paint, which fit it so well for lyrical expression, did not count for much with him.

It might almost seem as if the peculiarities and misanthropy of this early period provided the natural protection of his genius during the lean years before his imagination had taken fire. It lasted some time. The painting of the dead peasant, in 1910, is the first indication of spontaneous and emotional inspiration ; and of a general mobilization of his whole armoury of expression ; for it is noteworthy that in this work the *tridimensional* attribute of form gets its first wholehearted acknowledgment. To a less facile draughtsman this

great principle, containing as it does the germ of so much that inspires modern exploration, must have long ago claimed attention as a craft mystery, with emotional rewards of its own. Its belated invocation in Lamb's case, in the cause of what might be described as a purely literary sentiment, is extremely significant and illustrative.

From this time onwards the story of his work is the story of a mind no longer on the defensive, but responding with continually widening sympathies to the epic significance of all that life contained for him. His progress is marked by the reclamation of new territories of theme, and a continually widening field for expression, to which the language of style is constantly being adjusted or extended ; it is distinguished in this respect from the more intensive development which accompanies a gradual sublimation of temperament in the case of most English and probably all French artists.

The wider range of vision which his soldiering experiences brought him, with the new future which the genre picture seemed to hold for him, when approached in something of Chaucer's spirit, had a curious effect on his style. Simple and direct as had been the handling in his 1912 and 1913 performances, there was still too much of formula and calligraphy for his new purpose, in which the design must stand or fall entirely on its own significance and the treatment was to be allowed to

contribute neither emphasis nor simplification. The justification of this new experiment with its pre-Raphaelite tendencies came quickly enough, as the first of his war compositions testifies. The grandiloquence of the traditional battle-piece is a dead language compared to the simple and inspiring narrative of this human document. His new style, however, leaving this work out of account, must be regarded as belonging to a transitional phase, a discipline in statement which he was slow to relax. Not until the painting of the second family group was the quality of the paint again allowed an emotional share in the representation.

I have already referred to the first war picture (Plate 10) painted in 1919 for the Imperial War Museum; it is something of a portent. So instructive an example of his way of looking at things and so extreme an instance of his performance warrants a careful examination of it in this place.

To begin with, the choice of a slice of plain narrative for a theme is characteristic. It reveals a wise and modest understanding of what would make the best kind of contribution to the large body of work invited for the Imperial War Museum. There was less room here for allegory or epitome than would be permissible in the smaller Manchester collection; consequently we are confronted with just such a piece of ordinary illustration as a war correspondent of the last century might

18

have been expected to send home from Plevna or Kars ; the only difference being that the correspondent would probably have selected an episode of more military importance and provided it with more pictorial setting. The scene is laid in a natural amphitheatre in a fold of the Judæan hills, and towards the close of day the ordinary routine has been suddenly interrupted by a bombardment. It is probably not an incident of much importance ; merely the sort of spasmodic visitation to which, like a dust storm, even a quiet part of the line would be liable. Two of the shells have already landed and burst, and a rush for shelter is still going on.

Never, probably, has an important canvas, entailing months of work, been undertaken with such an intrepid disregard of the ordinary axioms of design. Although there was nothing but memory to draw upon, the composition provided none of the simplifications likely to produce a telling result and at the same time minimise the difficulties of execution. The interest of the design was to be scattered uncomfortably over the canvas. The figures were to be drawn on an intractable scale and in isolated groups that would defy any full-bodied and plastic handling in themselves, but which left them sufficiently important to obstruct any impression of volume in the realisation of the landscape background. To orchestrate the values

and the detail so as to produce any co-ordinate impression would, in the ordinary way, mean weeks of experiment or a very tentative method of approach. Yet, as is easily seen on inspection, Lamb was able to paint the work straight off, without correction or revision, completing it as he went, and the impression of spontaneity which the result leaves on the eye is so complete that the deliberation observable in every detail comes as an added fascination.

It would be a mistake to expect to discover in artifice the secret by which the artist has brought to life on the canvas this ineffaceable memory of a crowded moment. There is nevertheless an interesting thing about the picture which I believe has something to do with it.

I have already observed how he rose to an occasion in the painting of the dead peasant, and how the third dimension of form received therein a good deal of emphasis. In this war picture the quality is notably absent. As I pointed out, the character of the design discourages it, and the broad low sunlight provides the kind of illumination in which this quality is not unduly missed. There is, I think, a significance in this tridimensional deficiency, for in this case it seems to invoke a new principle, essential to the meaning of the work. This I hope to be able to trace without becoming too much involved in the science of æsthetics.

HENRY LAMB

Anyone who has looked at photographs through a stereo-scope must be familiar with the mysterious change which comes over the objects as soon as they emerge into relief. The stillness and silence of a frozen world suddenly pervades the scene and the objects wear an appearance of petrifaction. This must surely mean that the representation of solidity has in some enigmatical way invoked a SENSATION OF TIME. To account for this strange intrusion would involve too much æsthetic enquiry for the present purpose. It is enough if I have established a connection. It explains to a certain extent the mysterious fact that represented solidity has greater import than solidity itself, and in Art is an elastic quality capable of intensification. This obscure connection between form and time obtains further corroboration when we look round at the work of those painters who have proved themselves masters of what may be called *Moment* in Art, in whose works a feeling of the passage of time has been recaptured.* In Giorgione's *Concert*, in the Louvre, one almost hears the water flowing from the pitcher in a pause of the music, and it is more than a coincidence that in no painting is the sense of girth more bountiful and

* An example which supports my contention is to be found in Millet's picture *The Gleaners*, where the tridimensional realisation is so powerful that it immobilises the two moving figures and goes a long way to neutralise the strong dynamic feeling which animates the drawing and composition.

satisfying.* The *Beata Beatrix* of Rossetti in the Tate Gallery affords an example nearer home. The design is completely tridimensional, unusual in Rossetti's work, and Time is largely the motive in the conception. The pose of the head, arrested in a long trance, the duration of which the shadow seems to record as it creeps almost visibly round the sundial in the landscape, is full of the emotion of passing hours.

In the war picture all this is reversed. The moments do not pass. Time appears to stand still or to be turned backward. The tents look as they looked all the afternoon. The intensity of the moment falls with irregular incidence over the scene, suggesting the interval between a flash and the report, and it is in this vacuum of time that three distinct speeds seem to emerge, free to set up a kind of syncopated rhythm in which the soul of the picture speaks ; the men hastening to shelter, the slower gait of the smoke as it drifts over the stones, and

* If the actual action depicted in this work is examined it will be noticed that the one movement which registers the " Andante " of the piece and relieves the group from stagnation centres in the head of the right-hand musician. In his important place in the scheme, the patch of light on his cravat is all the emphasis that he needs, and the action can consequently dominate the design without too great a share in its plastic elements. The eye travels naturally to this focus where the romance of the picture finds a passionate outlet in the subdued tones of the shepherd's face. Here the feeling of time stored, as it were, in the rest of the composition spends itself in movement.

the imperceptible growth of the little plants. Had the effect miscarried there is nothing which would have held the picture together. All the elements of disintegration are there. The meaning would have been dissipated in isolated drama and the presence of the plants would have been misread as a tedious piece of symbolism.

We find, in short, the idea of Time completely dominating the scene, and in coming to examine the painting we marvel at the art in which all the elements, the nature of the theme, the untoward design with its absence of focus and its un-satisfied plastic impulses, the complexity of the movement together unite in riveting the attention on this great emotional realisation.

It will be noticed at once how admirably the pre-Raphaelite delicacy of the treatment suits the subject, and in fact provides the only language for its meaning. The clockwork precision of the drawing invests the action with an air of cosmic mechanism, and the vivid colours suggest the texture of intense life, which gives relevance to the actual beauty of the landscape.

Like all Lamb's work it is literary in inception, at any rate, in so far as it presupposes a measure of civilized experience in the spectator, who must, for instance, be conversant with the properties of gunpowder, if he is to grasp its full meaning ; and

the suggestion of surprised valour, if the incident in the foreground may presume to such a description, has certainly an anecdotal origin. It is presented, however, in terms of sensation, and derives its psychological significance from its share of the timeless quality I have endeavoured to describe.

The second war composition (Plate 11) painted at the request of the Corporation of Manchester, has a subject which, like that of its predecessor, is an ordinary piece of illustration, but which is more monumental in its range and application. The facts of the scene are presented with the same logic as in the Palestine example. The spectator is supposed to view it from the entrance of an advanced dressing-station. A group of stretcher-bearers stand by at the rendezvous, waiting to be despatched on their several tasks during the coming night.

A sculpturesque tridimensional treatment of the group and the landscape background suggests the monotonous passage of the minutes of tense expectation which is the mood of the picture and of the figures, to which the activity in the immediate foreground is the foil. The details are treated with the same minute realism. The footmarks in the mud are reproduced with an almost emotional fidelity. The humour and humanity of the delineation of the stretcher-bearers is incorporated with an almost Shakespearean art into the generalised grandeur of the

24

idea ; indeed, a quotation from the first part of Henry IV is the best possible illustration of Lamb's own use of humour and detail, and indeed the character of the dialogue is not inappropriate to the picture under review.

ACT II. SCENE I.

Rochester. An inn yard. Enter a carrier with a lantern in his hand.

FIRST CARRIER. Heigh ho ! An't be not four by the day I'll be hanged. Charles' wain is over the new chimney, and yet our horse not packed ! What, ostler !

OSTLER (*within*). Anon, anon.

FIRST CARRIER. I prithee, Tom, beat Cut's saddle, put a few flocks in the point ; the poor jade is rung in the withers out of all cess.

Enter another carrier.

SECOND CARRIER. Peas and beans are as dank here as a dog, and that is the best way to give the poor jades the bots ; this house is turned upside down since Robin Ostler died.

FIRST CARRIER. Poor fellow. Never joyed since the price of oats rose ; it was the death of him.

SECOND CARRIER. I think this be the most villanous house in all London road for fleas ; I am stung like a tench.

HENRY LAMB

There is no need to point out the consummate art which has made this small scene of carriers tightening the girths of their pack-horses in the small hours of the morning the thrilling prelude to the adventures of the coming day. The full meaning of " Act II, Scene I " in the hands of a master of stage-craft such as Shakespeare or Mozart is realised in all its bearing. The mood is already established, the speed of the action developed, and the great figures of the drama are in our minds. The trivialities of the homely dialogue can now take their place in a wide perspective, and the momentum of a great design relieves the salience of the detail from the sophisticated accent of symbolism. It is in his treatment of details of this kind that we recognise in Lamb's work something of the same poignant sense of humanity which can bring its humours into a romantic relation with the more static grandeurs of natural law. In this picture there is surely some of the magic of " Charles' wain over the new chimney."

What, contributes to the presence of this Shakespearean feeling in Lamb's work, and transmutes it from a dramatic into a pictorial attribute, is a vivid and almost EMPATHIC sense of physical values. The war provided a whole planetary system of circumscribed movement. The Infantry, the Air Force, the Artillery, the A.S.C., and the R.A.M.C., each moved in an immutable orbit of its own, and lived with its

own focus and horizon. It was instructive to notice in the contributions to the Imperial War Museum how strongly this was felt in the works of those who had been part of the military machine, and how much they differed in this respect from the productions of many of the official war artists who roamed at large in search of their subjects. Wyndham Lewis and Darsie Japp, to mention only two of the widely differing interpreters, reproduced in their works a strong impression of this kind. Spatial values, imagined in relation to the dynamics of human action, make a momentous contribution to the psychology of pictorial representation. In the case of Lamb, a lively sense of their import distinguishes the *mise en scène* of most of his work. Lytton Strachey is preserved for us in a lofty room, to which the unusual expanse of landscape seen through the vast window lends some of the character of a cage. The second family group has a very definite place in its somewhat baffling surroundings, and it is not surprising that in his hands the architecture of the battlefield has a logic and significance of its own. In the Palestine picture the projectiles arrive over the rim of the amphitheatre with the same effect of intrusion as stones splashing into a pond, and the near horizon suggests the fabric of intimate camp life, whose tranquil monotony they have disturbed. In the Macedonian example the orbit of the R.A.M.C. finds its vital focus at the entrance of the dressing-

station. From here issues the inspiration of its mission, and it is here that the men will put down their loads. Beyond is the trackless darkening region of their activities. Into this elementary world the great truths and the small fall easily into their places ; and the trivialities of discomfort and routine assume their natural importance in the poetry of life.

This picture is essentially more of a generalisation than the Palestine one, and it is impossible not to feel that the pre-Raphaelite treatment which reinforced in the latter the impression of intensity, suits this work less well, and appears to have a slightly confining effect. To judge from a preliminary sketch for this work which was recently exhibited, its beautiful colour would seem to have demanded rather more adjustment in translation to a more epic scale. One feels that a quality is lacking which might have carried this noble conception a stage further. The rhetoric which Augustus John can infuse with so little of bombast comes into one's mind ; or the roominess which is so magical a quality in the colour of Duncan Grant. Here the colour is dignified and luminous, but on looking at the picture for the first time one seems to meet it too soon. Had the work been carried out in any other medium than oil paint, the frugal directness of the handling might have belonged to the material rather than to the artist. As it

is, and with so resourceful a craftsman behind it, it has a symptomatic look.

The Puritan circumspection which has characterised his style since the outset of his career reflects a pre-eminently intellectual outlook. The generous inflections of the Grand Manner, with its exhuberance and random æsthetic fascinations belong essentially to a language used to enfranchise a platitude or to set free a general idea. Here, on the other hand, is the careful speech of definition, perfected in the task of capturing an elusive conception, and enclosing a rare turn of thought.

The place which Henry Lamb will hold in the history of English art would not be easy to assign. His is a remarkable but baffling personality, and it is too early to prophesy on what lines it may still develop. He has no imitators ; but possibly his influence on others has been greater than one might be led to imagine. The peculiar novelty of conception which belonged to the female portrait already referred to when it first arrived over the Channel no longer exists for us. Although its intrinsic beauty survives, the lyrical feeling which animated it has since become familiar to us through other hands and in a no less personal way.

Of his more characteristic work few elements could be transmitted or shared, inasmuch as it comes of a mental endowment peculiarly his own. His work seems unlikely to

provide any direct link in the chain of artistic advance and discovery. It would be strange, however, if to a temperament so lively and illumined with an outlook so entirely generous there should be no successors. Possibly, as might be said of Hogarth before him, the goodwill of his personality will remain the permanent possession of his country, available to any that come after and would follow him in the art of human commentary which has acquired so much dignity at his hands.

G. L. K.

PLATES

PLATE 1. DEATH OF A BRETONNE. (1910).
Oil. In the possession of Prof. Sir Michael Sadler, K.C.S.I.

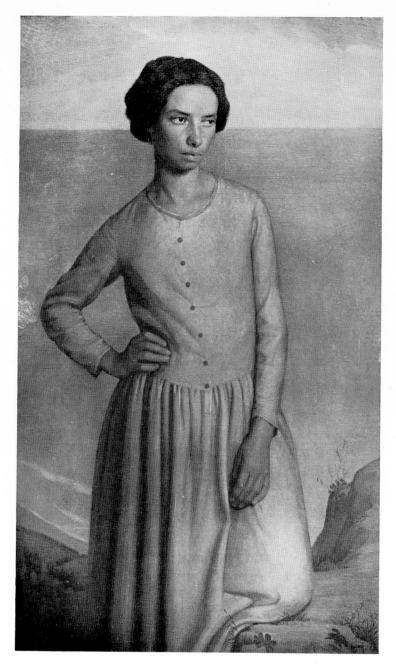

PLATE 2. PORTRAIT. (1911).

Oil. In the possession of Prof. Sir Michael Sadler, K.C.S.I.

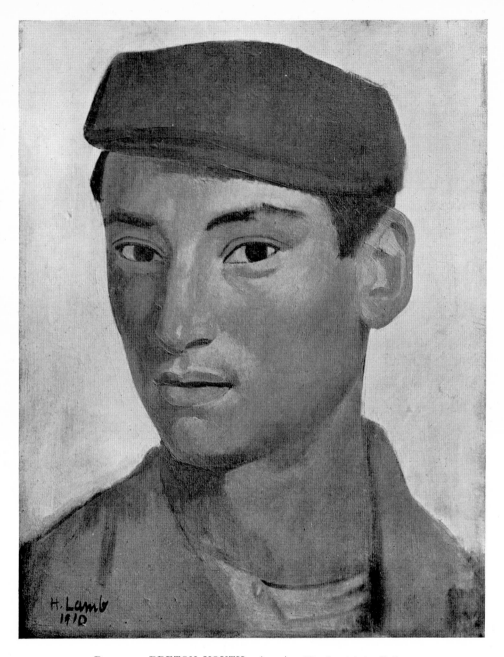

PLATE 3. BRETON YOUTH. (1911). *Oil. In a private collection.*

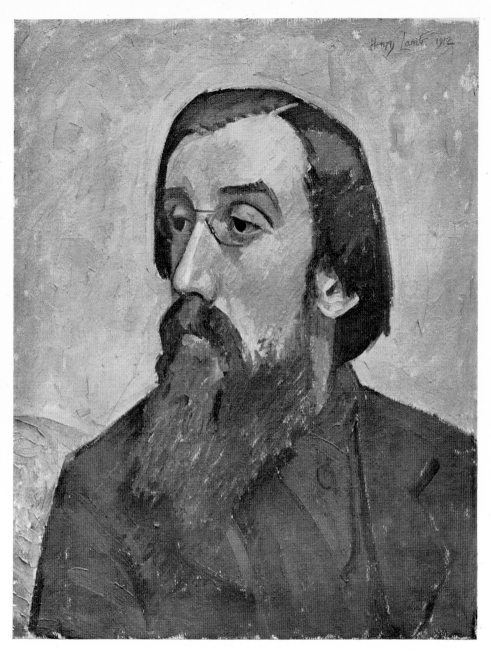

PLATE 4. LYTTON STRACHEY, ESQ. (SKETCH). (1912).

In the possession of the Lady Ottoline Morrell.

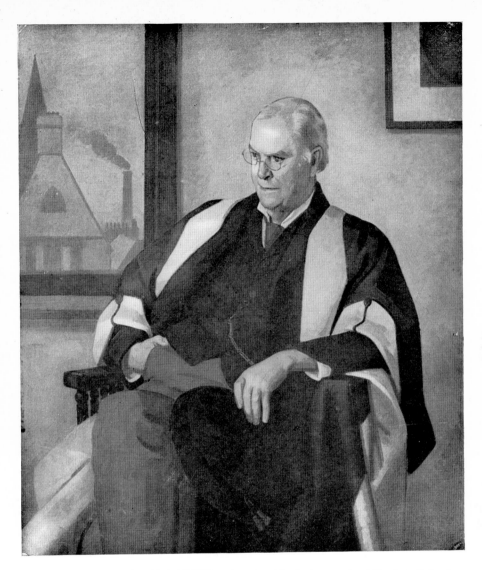

PLATE 5 THE ARTIST'S FATHER. (1912). *Oil. In the possession of Manchester University.*

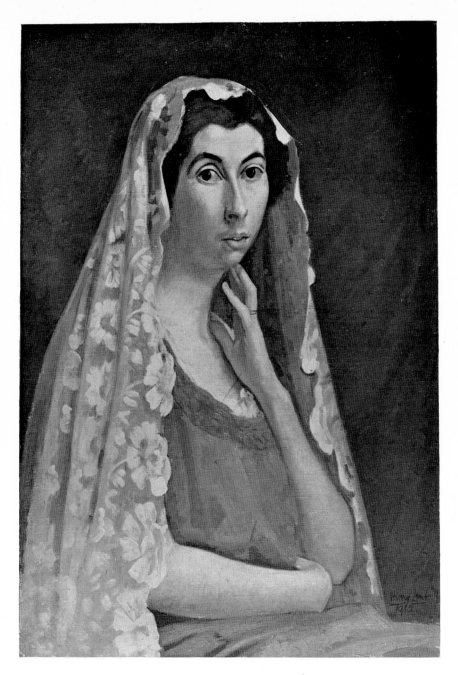

PLATE 6. MRS. J. L. BEHREND. (1912). *Oil. In the possession of J. L. Behrend, Esq.*

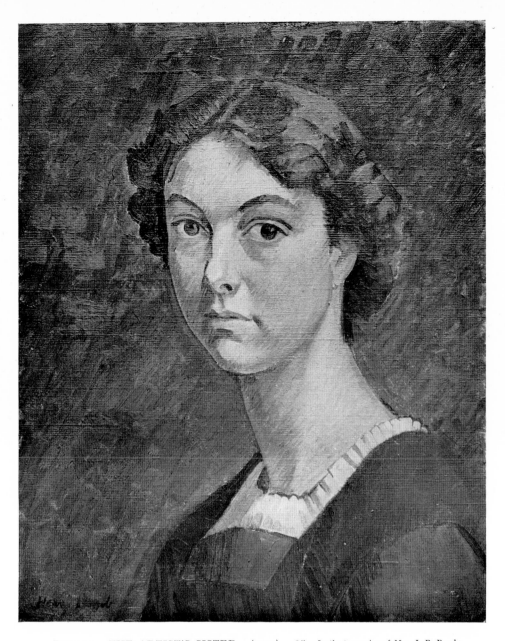

PLATE 7. THE ARTIST'S SISTER. (1912). *Oil. In the possession of Mrs. J. R. Brooke.*

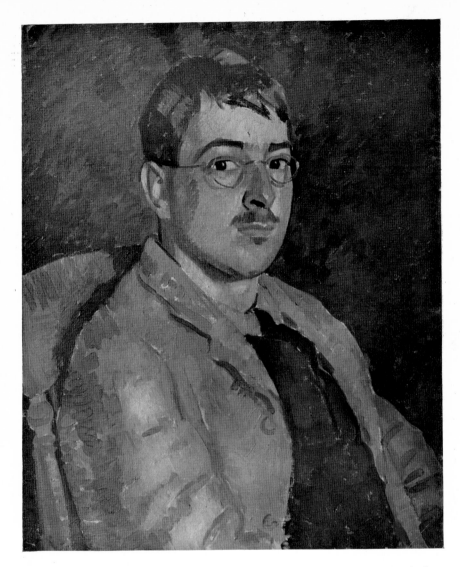

PLATE 8. GEORGE KENNEDY, ESQ. (1913) *Oil. In the possession of G. L. Kennedy, Esq.*

C

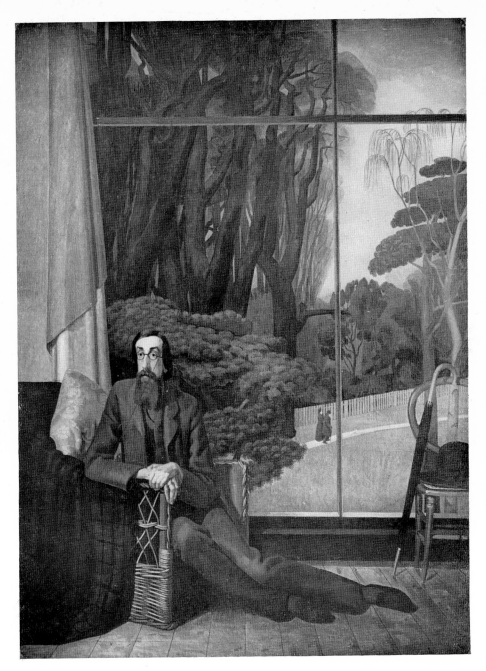

PLATE 9. LYTTON STRACHEY, ESQ. (1914). *Oil.* *In the possession of J. L. Behrend, Esq.*

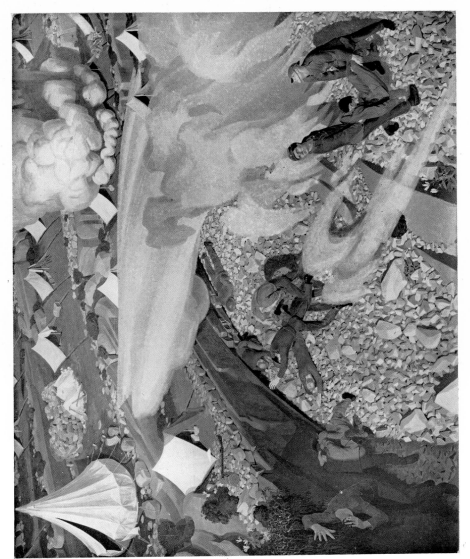

PLATE 10. PALESTINE WAR PICTURE. (1919). *Oil. The Imperial War Museum.*

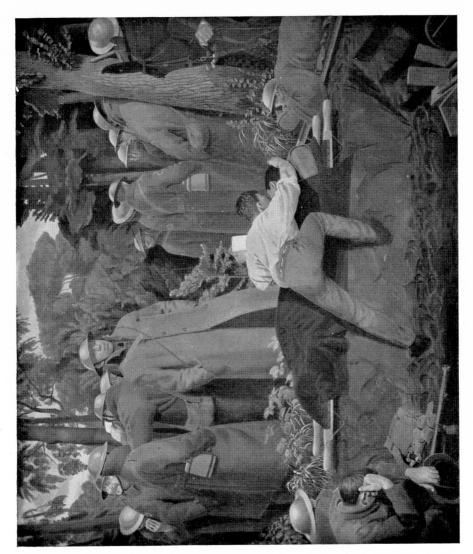

PLATE II. SALONIKA WAR PICTURE. (1920). *Oil. Manchester City Art Gallery.*

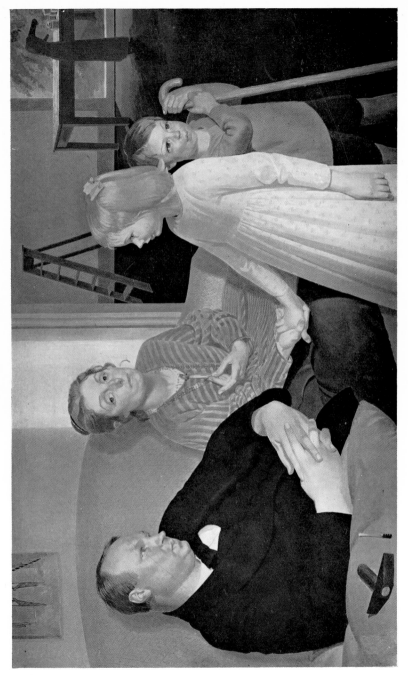

PLATE 12. THE ANREP FAMILY. (1920). *Oil. In the possession of B. Anrep, Esq.*

D

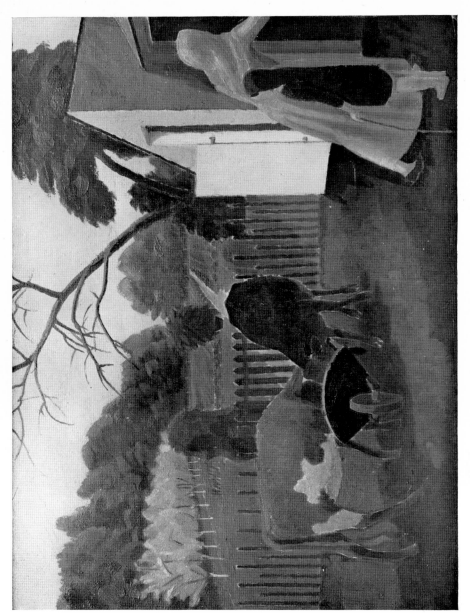

PLATE 13. FEEDING CALVES. (1921). *Oil. In the possession of C. E. Bechhofer, Esq.*

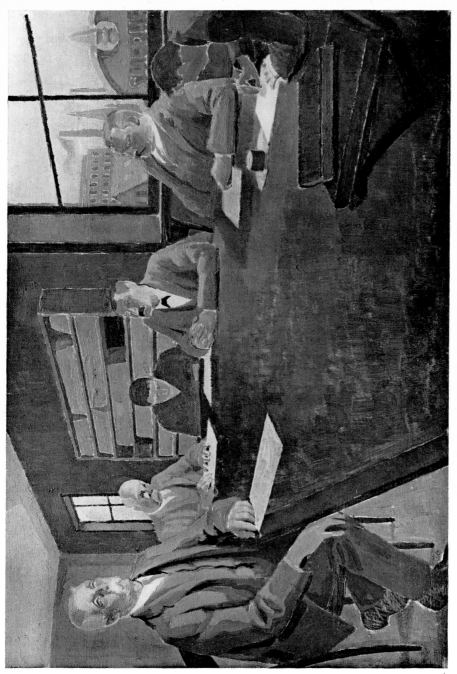

PLATE 14. A BRISTOL COMMITTEE. (1921). *Oil. In the possession of C. E. Bechhofer, Esq.*

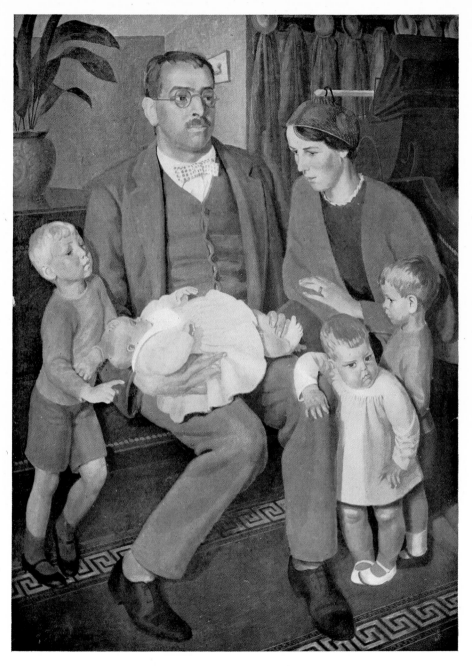

PLATE 15. GEORGE KENNEDY AND FAMILY. (1921).

Oil. In the possession of J. L. Behrend, Esq.

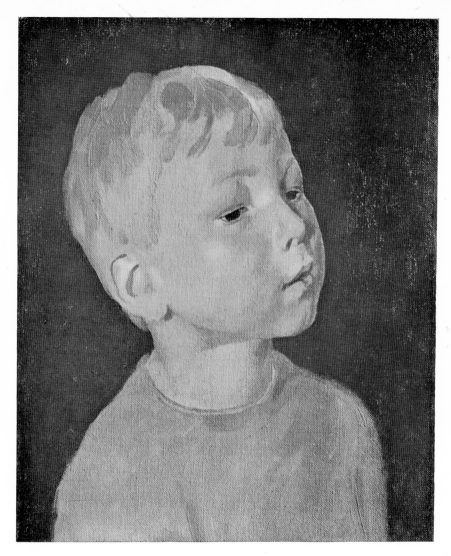

PLATE 16. CHILD'S HEAD. (STUDY). (1921). *Oil. In the possession of Mrs. L. Kennedy.*

E

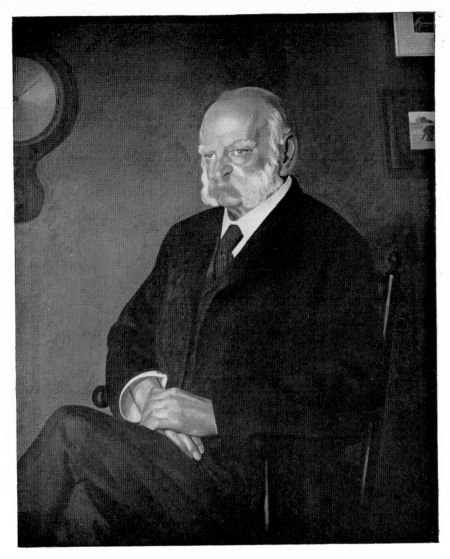

PLATE 17. FRANCIS JONES, ESQ. (1921). *Oil. In the possession of Francis Jones, Esq.*

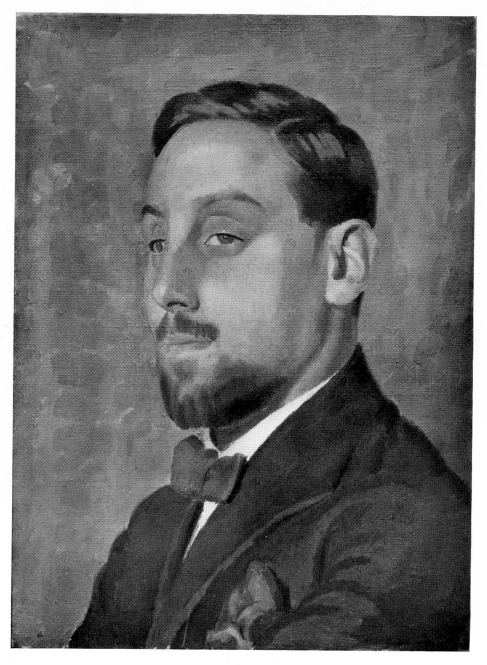

PLATE 18. C. E. BECHHOFER, ESQ. (1922). *Oil. In the possession of C. E. Bechhofer, Esq.*

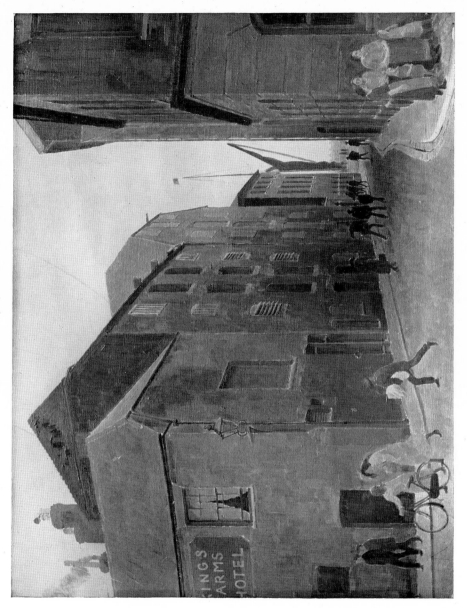

PLATE 19. PARADISE STREET, POOLE. (1922). *Oil. In the possession of the Artist.*

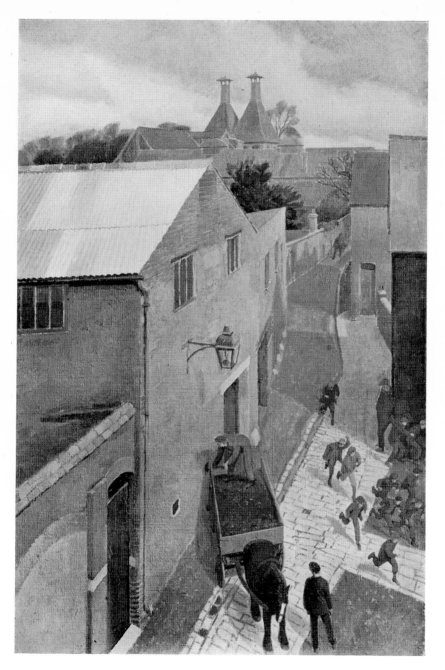

PLATE 20. DEAR HAY LANE, POOLE. (1922).

Oil. In the possession of J. L. Behrend, Esq.

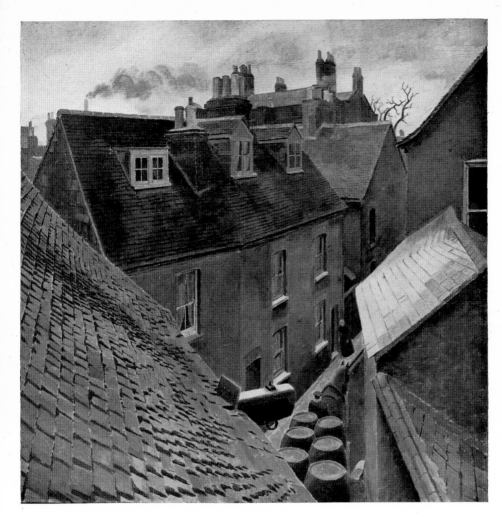

PLATE 21. ROOF VIEW, POOLE, No. 1. (1922). *Oil. In the possession of Lord Henry Bentinck, M.P.*

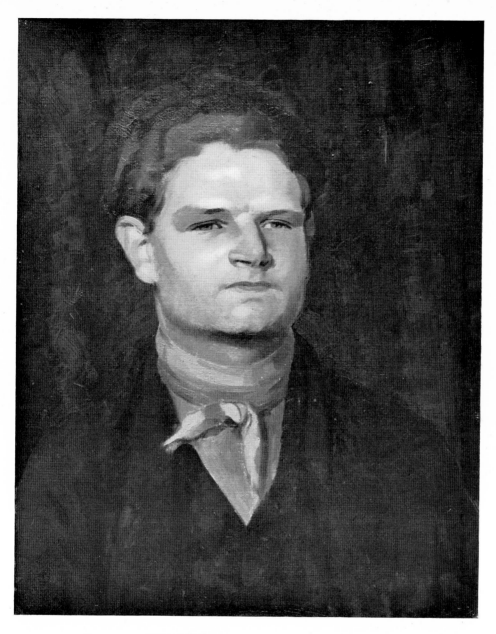

PLATE 22. THE DOLER. (1922). *Oil. In the possession of the Artist.*

PLATE 23. THE BIVVY, PALESTINE. (1923). *Oil. In the possession of J. L. Behrend, Esq.*

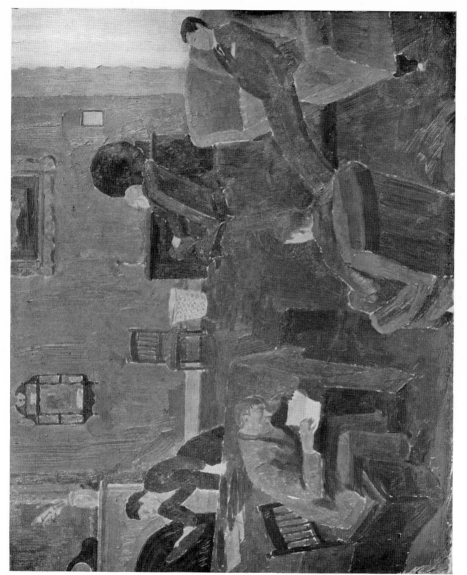

PLATE 24. THE GRAMOPHONE. (1923). *Oil. In the possession of J. L. Behrend, Esq.*

G

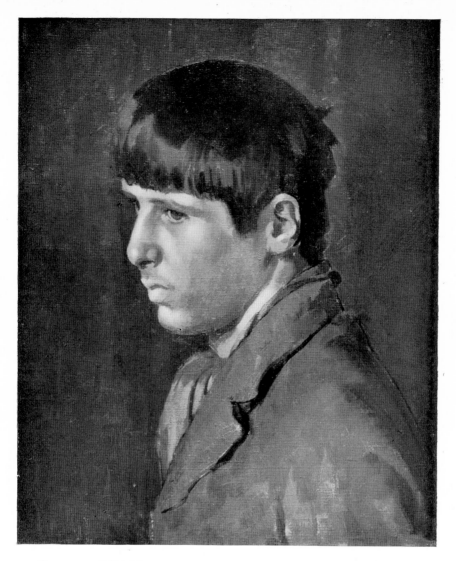

PLATE 25. ROMILLY JOHN. (1923). *Oil. In the possession of Mrs. D. Behrend.*

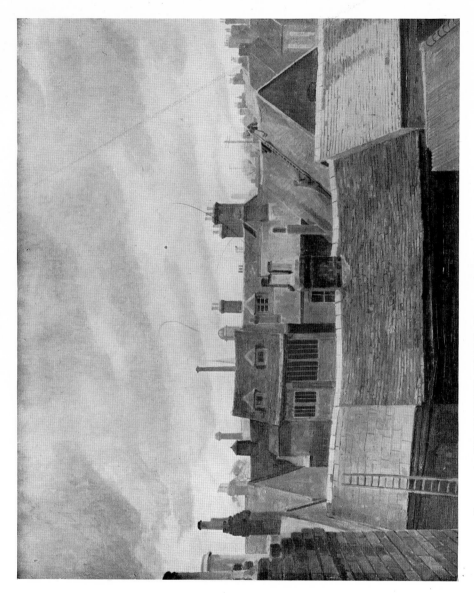

PLATE 26. ROOF VIEW, POOLE, No. 2. (1923). *Oil. In the possession of the Artist.*

PLATE 27. THE PROVOST OF WORCESTER. (1923). *Oil. Worcester College, Oxford.*

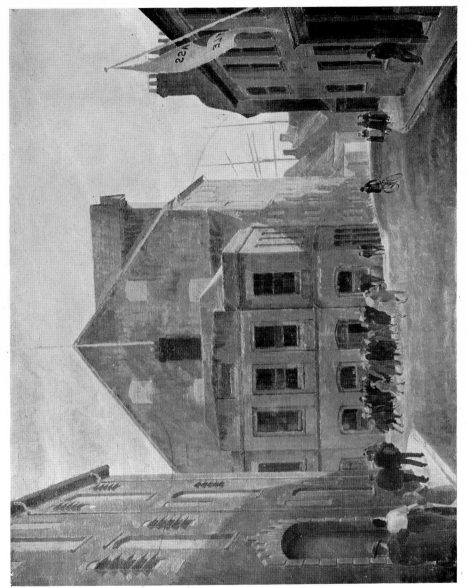

PLATE 28. HIGH STREET, POOLE. (1923). *Oil. In the possession of the Artist.*

H

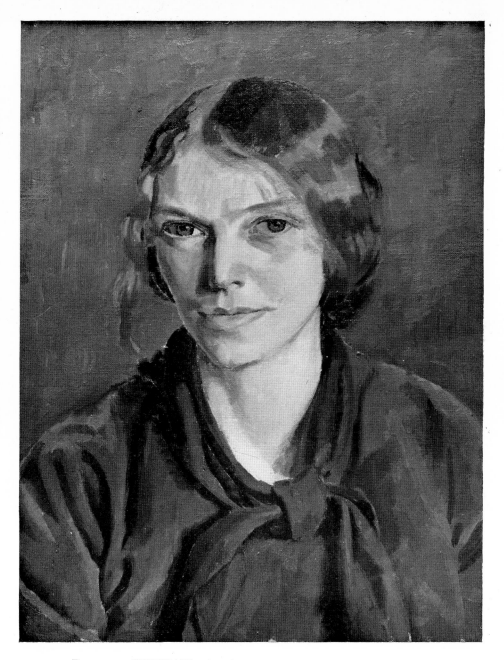

PLATE 29. PORTRAIT. (1923). *Oil. In the possession of Gerald Summers, Esc.*

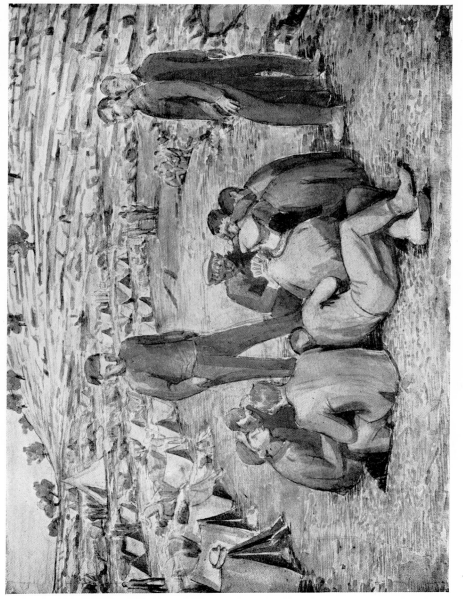

PLATE 30. CARDS BEFORE "STAND-TO," PALESTINE. (1918). *Water colour drawing. In the possession of the Artist.*

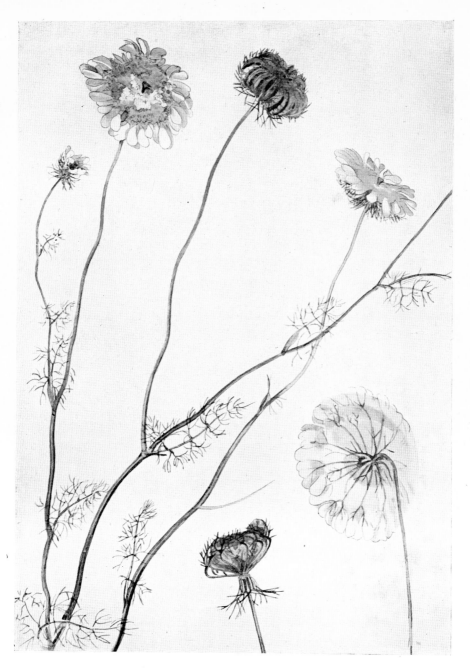

PLATE 31. FLOWER DRAWING, PALESTINE. (1918).

Pencil and water colour. In the possession of the Artist.

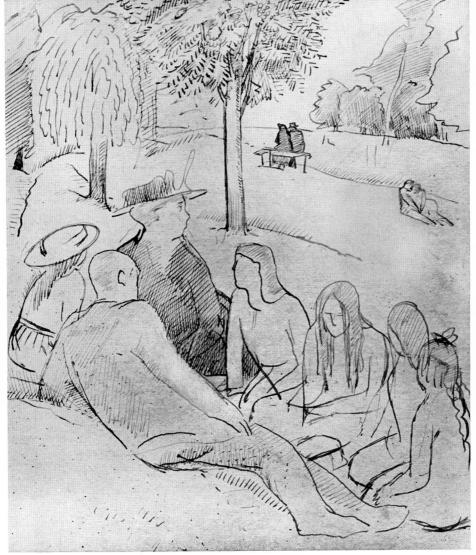

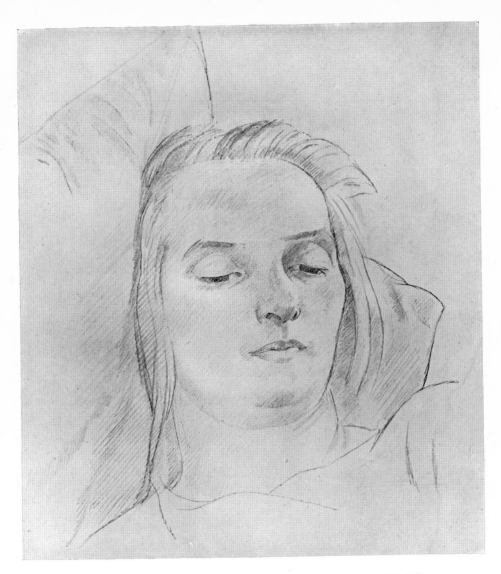

PLATE 33. A HEAD. (1920). *Pencil drawing. In the possession of the Artist.*

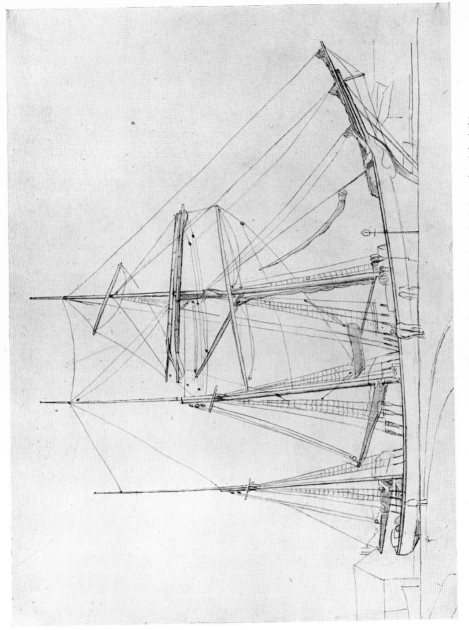

PLATE 34. BARQUENTINE. (1922). *Pencil drawing. In the possession of the Artist.*

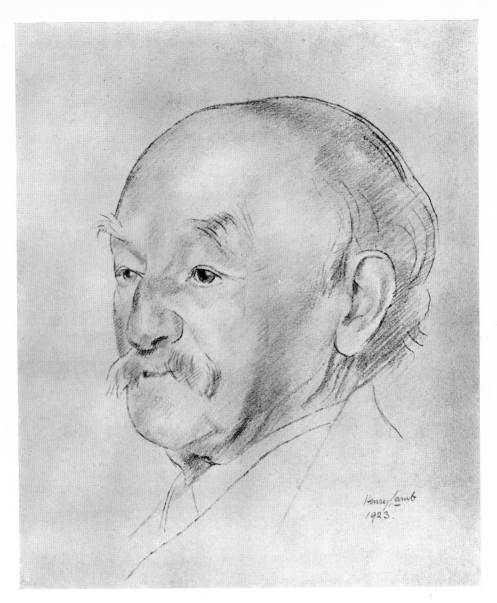

PLATE 35. THOMAS HARDY, O.M. (1923). *Pencil drawing. In the possession of the Artist.*